The Henry Moore Gift

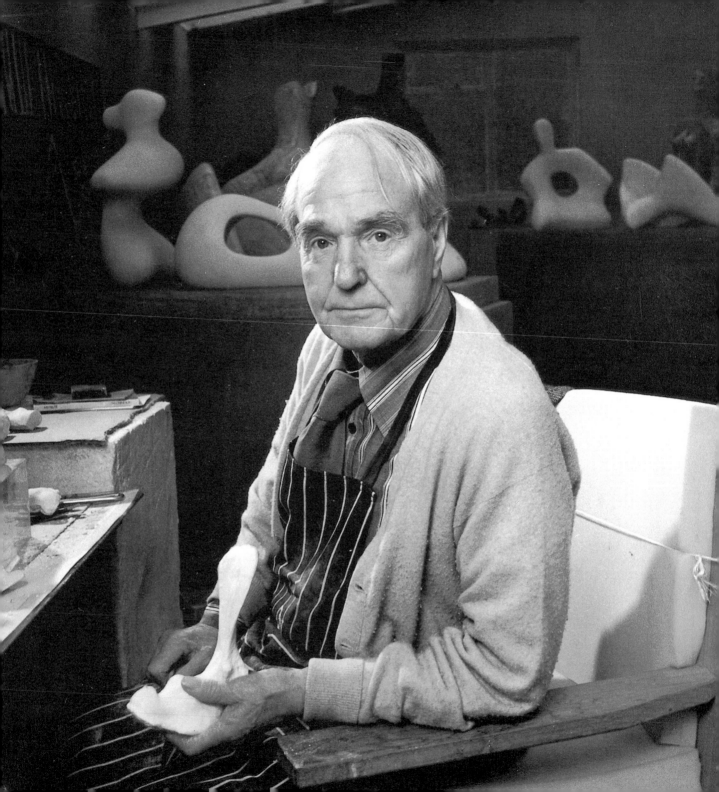

The Henry Moore Gift

a catalogue of the work by Henry Moore in the Tate Gallery collection
published to celebrate the artist's recent gift of sculptures

Tate Gallery 1978

ISBN 0 905005 26 0
Published by order of the Trustees 1978
for the exhibition of 28 June–28 August 1978
Copyright © 1978 The Tate Gallery
Published by the Tate Gallery Publications Department,
Millbank, London SW1P 4RG
Designed by Sue Fowler
Printed in Great Britain by Balding & Mansell Ltd, Wisbech, Cambs.

cover
Working model for
Three Piece No.3: Vertebrae, 1968 (detail)

frontispiece
Henry Moore photographed by Bern Schwartz

Contents

Foreword

Henry Moore's association with the Tate goes back many years. The first of his sculptures to enter the national collection was one of his finest carvings – the 'Recumbent Figure' of 1938 which was presented by the Contemporary Art Society in the following year.

In 1941, Henry Moore, then an official War Artist, became a Trustee of the Tate and remained on the Board, with one brief interval, for fourteen years. This experience must have been not entirely dispiriting because he later became a Trustee of the National Gallery – a generous gift of his time to the public collections out of an immensely busy life. His years as a Trustee of the Tate covered a productive period when the Gallery was coming to life again after the war. One of Henry Moore's practical suggestions, I remember, was to try to knit together the display of paintings and sculpture more closely so that the visitor in going round the room would at intervals discover a piece of sculpture as part of the arrangement of the wall. Henry's dissatisfaction with the common practice of putting sculpture in the middle of the room stemmed from his belief that many visitors tend to coast round the walls and simply do not see sculptures placed in the body of the room.

The Tate had no purchase fund before 1946 except for a few hundred pounds a year from the Knapping Fund. Out of this small sum three drawings by Henry Moore were bought in 1940, and in 1945 seven bronze maquettes, three for the 'Family Group' and four for the Northampton 'Madonna and Child'. This nucleus of works was slowly added to over the years and a number of major works were acquired, virtually at the cost of casting, through the generosity of the sculptor.

The possibility of the sculptor presenting a large group of his work to the national collection was first discussed in 1964 and during the following years the list was added to and dovetailed into the Tate's own holding.

Henry Moore attached no conditions to the display of his intended gift, but, perhaps foreseeing those who, unaware of this, had fears that a substantial group of his work might swamp the collection of twentieth-century British art, he decided that his gift should become effective only when the exhibition space at the Tate had increased by fifty per cent. The new extension to the Tate provides this increase and

but for troubles with the atmospheric control the building would have been in use long before now.

When it became evident that Henry Moore's 80th birthday would arrive before the opening of the extension, I asked him if he would agree to make his gift so that it could be shown as part of his birthday celebrations and he willingly agreed. It is a magnificent and immensely generous gift and together with the works already in the Tate, nobly represents Moore's achievement.

Norman Reid, Director

Introduction

It is a great thing, and a rare one, for an artist to go on treading new ground as he grows older. And it is the greater and the rarer when that artist has caught the public's fancy, all over the world, with one particular sort of work. Henry Moore has done this more than once in his career; and if he had then quietly dropped out, or gone on repeating himself, he would have remained a general favourite. A certain kind of reclining figure, a certain kind of family group, and a certain kind of stylized totem would have gone on winning him new admirers. Older enthusiasts could have kept, meanwhile, that fixed and dependable image which is one of the secrets of fame. Most people can only stand a certain number of surprises.

To overcome the inertia which success can bring with it, an artist needs three qualities, and he needs them in combination. The first is an inner ferocity. This has nothing to do with the outward flamboyance which even very bad artists can sometimes display. It is a matter of purposeful activity far beneath the levels of outward behaviour: a matter, one could say, of constantly steering into the wind at times when it is tempting to run before that wind with the rudder locked in position and ourselves horizontal in a hammock. Second, the artist must command an idiom which will never break down or stop developing just when he needs to encompass some entirely new statement. Third, the big artist must sense what people need at a given moment in history. This awareness has nothing to do with social realism, and even less to do with the market. It cannot be got by reading the newspapers. An artist can miss it, in fact, by getting too close to current events; and he can miss it by getting too far away from them. Political involvement on the one hand, and narcissism on the other, can alike be fatal. But if an artist has all three qualities; if he consistently takes the line of most resistance, if the idiom of his art allows of continuous development, and if he is (so to say) on a direct line to our collective psyche, then he is likely to do great work.

All this applies directly to Henry Moore. Of the master-qualities which I have just listed, the inward ferocity is much to the fore in the Henry Moore gift. Most collectors are happier with images of calm and repletion than with images of terror and disquiet; and the exhibition is certainly very strong in what Moore calls his

'tender' vein. But it is with the contrasting 'tough' idiom that he has usually turned up-wind and met difficulty head-on. For this reason it is a great stroke of good fortune that the collection should have been enriched by 'Animal Head' 1956, 'Headless Animal' 1959 and 'Three Part Object' 1960, which by now have kept their secrets intact for two decades.

Quality number two – the capacity to keep the idiom alive – is also very well displayed in this exhibition. It may be difficult, in this context, for one who has grown up alongside of Moore's work to foretell its effect on an audience which is too young to have had first-hand experience of the complex of experience which has been available to the English sculptor of Moore's generation. For our response to Moore's work has gone through as many metamorphoses as the work itself. Initially, in the early and middle thirties, he seemed almost impossibly 'difficult' to a public that knew nothing of modern art. 'Four Piece Composition' 1934 is a good example of this: to get the point of it before 1939 called for a familiarity with the international scene that very few English people then possessed.

Moore in the 1930s could make half-length figures like 'Half Figure' 1932 which have the poignancy of portraiture. But he was also interested in the structure of animal-heads, and in the snouts, slots, and spoon- or shoe-shaped areas of bone which they included. These things were never just copied, but an echo of them could find its way even into pieces like 'Figure' 1931 and 'Composition' 1932 which were basically naturalistic.

Moore, by the late 1930s could also take elements from the human body and combine them as in 'Recumbent Figure' 1938 with elements from landscape. What resulted was an independent poetical structure which reminded the observer now of a woman's breast or belly or thigh, and now of natural stone-forms worn by wind or water into shapes suggestive of an evolution slower, grander and more august than our own. The interplay between these possibilities added something, forever, to the repertory of art.

Moore's pre-war carvings have a fatal quality, as if the artist were risking his career afresh with each one of them. And he was, in fact, coming to terms successively with one powerful experience after another. What he is now comes directly from what he was then, and he would not be what he is now if he had not known how to handle the intense and seemingly contradictory experiences of 1922–39.

These experiences fell into four main groups. There were the works of what was then called 'primitive art' which Moore studied on half-holidays in the British Museum. Art-literature was not then as comprehensive as it is now, and in the early 1920s a young artist who wanted to get the hang of Mexican sculpture had no alternative but to get down to London and make a habit of going to the Museum. Every writer on Moore has pointed out the similarity between his early reclining

figures and the Mayan figure of Chacmool, the Rain Spirit. And everyone, likewise, has quoted Moore's remark that 'Mexican sculpture, as soon as I found it, seemed to me true and right'. What they have not always quoted is the continuation of that sentence: '. . . true and right, perhaps because I at once hit on similarities in it with some eleventh-century carvings I had seen as a boy on Yorkshire churches'. Moore was stimulated, quite obviously, by the direct and barbaric element of Mexican art; but what he needed as a young man was not so much the stimulus of alien imagery as the enfranchisement which comes from knowing that one's earliest memories are part of the unity of all human experience. Any lively young person today can scamper through the panorama of known art and pick out the things that excite him; what stirs a serious artist is the feeling of authorization, the inner signal to go ahead, which comes when he realizes that an illimitable repertory of unconscious images is within each of us, only asking to be brought upwards to consciousness.

Next came the great masters of the Renaissance. Moore's is a slow and thorough nature, and the deeper the experience, the slower and more thorough is his reaction to it. You would have had to be very bright indeed, in the 1930s, to guess that one of his deepest allegiances was to the works of Italian art which he had studied during a six months' visit to Florence and elsewhere in 1925. Not until the period 1943–47 did that allegiance find direct outlet. Initially the experience had a negative effect, in that it affected Moore so deeply that he was unable either to go on as before or to start on a new tack. How he eventually turned it to great uses will, I hope, appear later.

Third came the experience of what can be called 'the modern movement'. Here again, the information available to students was infinitely less than it is today. Only a small and oppressed minority had any contact at all with what was going on in Paris, and Moore's own knowledge was confined to more or less annual visits and the perusal of such magazines as came his way. But although he has never been one to take part in group activities, there was a period in the 1930s when he lived in London and was in close contact not only with Nicholson and Barbara Hepworth and Herbert Read but with such visitors from abroad as Mondrian and Gabo; and from all this he had a double reassurance. Not only was he not altogether alone in what he was doing, but he had the feeling that he would get to know the best that was being done elsewhere. This kept him well clear of the risk, tiny as that was, of taking on the cranky, ingrown traits of the isolated 'modernist'.

And, finally, he became aware of the universal cousinage of forms. As he put it in 1941: 'Through the working of instinctive sculptural sensibility, the same shapes and form-relationships are used to express similar ideas at widely different places and periods in history, so that the same form-vision may be seen in a Negro and a Viking carving, in a Cycladic stone figure and a Nukuoro wooden statuette.' And more than this, he related these same affinities to forms shaped by Nature. At a time when the

'found object' was elevated to the status of a work of art, Moore also was finding objects: but instead of putting them on show, he pushed them down below the level of consciousness and let them come up in their own time.

This, then, was the equipment with which Moore had provided himself by the outbreak of war. He also had nearly twenty years' actual physical experience of sculpture: for it is one thing to have a good idea for sculpture and quite another to carry it through – above all, in the medium which Moore used almost exclusively up till 1945: that of carving, in which every tap of the chisel is irrevocable. And he was still, in most people's eyes, a man of strange and inscrutable impulse. He had never repeated himself, he had never stopped even to consolidate, and he was still operating in areas where no one had learned to follow him.

When the war ended, six years later, all was changed. In 1939, the respected friend of a diminutive avant-garde, Moore found himself in 1945 the keeper of the national conscience: one of England's big men, firmly consecrated. This he had achieved with one major carving in a provincial church and a group of drawings. It is one of the most curious reversals of English art-history, or taste-history, that this should have come about so swiftly and as a result of work different from anything he had done before.

In part it was due, certainly, to our tendency at that time to look around for something that would make sense of the war and confer a lasting dignity upon what was in its cumulative effect a period of unmitigated exhaustion. Moore did this when he made drawings from the thousands of people who spent night after night in the underground at the time when the German air force was making regular attacks on our capital. And he did it again, though perhaps less obviously, when he produced the Northampton 'Madonna and Child' in 1943. This is the least 'modern' of all his works and, like the 'family groups' on which he began at about the same time (see the three 'Maquettes for Family Group' 1944–5) it brought to thousands of people an extraordinary feeling of serenity and repletion.

He showed, that is to say, the third of the qualities which I listed at the beginning of this essay: the sense of what people need at any given time – or, in this case, the sense of how much they could usefully bear. The time was not right for pieces like the Tate Gallery's 'Recumbent Figure' of 1938. Still less was the public ready for a piece like the 'Reclining Figure' of 1945–46 which formerly belonged to the Cranbrook Academy in the USA though this has a marvellous allusion to martial glory in the watch-tower-like head and the helmeted look of the huge wooden heart. Moore knew that the people had had enough of soldiering, and the theme of the warrior did not in fact come back into his art until two years after his first visit to Greece in 1951. What they wanted was an architecture of consolation, and they got it in piece after piece that spoke directly of the healing quiet of the hearth.

Allusions of this sort had always been present in Moore's work, for those who knew how to find them, from his early life-drawings onward. But they had never before been manifested so clearly, or to so large an audience. And once it got home to our public that the same accessible human being was present behind all his work, there came a wave of sympathy which had the effect, first, of setting him free to work full-time after many years of hard slogging as a teacher and, second, of creating a demand for his sculptures which by pre-war standards was unmanageably large. Moore, who, till 1939, had cast only a tiny percentage of his output in bronze, began to work regularly in this medium. Editions of seven, nine, ten or even twelve were made of many small pieces which in earlier days would have stayed in the studio, and a big new carving from his hand became relatively rare.

Initially the small bronzes related almost entirely to sketch-models for pieces in which the 'tender' side of Henry Moore was uppermost. With their relaxed Italianate style, the pocketable size, and their references to the closed circle of family happiness, they are probably to this day the most universally acceptable of all his works. Moore had said in 1937 that 'there is a right physical size for every idea', and some of these ideas had found their finest fruition in lifesize realizations like the Dartington 'Memorial Figure' of 1945. But at the time when so many people craved a souvenir of a major artist who had just revealed himself as an accessible human being, it seemed churlish to regret the multiplication of these little trophies. (Besides, they also existed in lifesize form: see 'Family Group' 1949).

Later Moore began to use the smallish bronze for ideas that were independent of any larger fulfilment, and the public which had responded so eagerly to his tender side was offered the chance of coming to terms with its opposite, the element of 'toughness'. An example of this is 'Animal Head' 1951.

'Tough' and 'tender' are Moore's own adjectives, but I must admit to finding them too summary. The contrast is, surely, between the transparent goodness of Moore's own nature and the irrational, mindless and all-but-invincible forces which every sensitive person knows to be abroad in the world. These irrational forces can be allegorized in terms of animals, or of the convulsions of wild Nature, but the truth is that they are present in all of us. Education and the conscious mind keep them more or less in control, but recent history shows how often they get the upper hand. Some sculptors would have tried to give them explicit shape, but Moore's strength lies in his command of meaningful ambiguity. His sculptures never have any one meaning. The larger ones are, in fact, like landscapes that take on a different significance at every stage in our exploration of them, and the smaller ones, like so many pieces in this collection, have the quality of epigrams that can be read this way or that and never fail to make sense.

There are, in fact, quite a few pieces by Moore in this collection which have in

them an element of terror. Even the hallowed theme of the mother and child takes on, in 'Mother and Child' 1953, a new dimension of psychic reality when we realize that the mother could be just about to throttle her child. Moore is not confined, in short, to the pacific view of family relationships which won him such popularity in the late 1940s and has been aiming to get an ever more powerful dramatic tension into his large pieces. The full hostility of our environment can come through: the fact, that is to say, that everything around us tends sooner or later towards our destruction: Nature, other people, and ourselves.

But this is not to say that Moore's is a pessimistic art. On the contrary: he favours a sturdy and a stoical response to the vicissitudes of life. From 1963 onwards he gave outlet to this point of view in a long series of big-scale reclining figures. Survival is their subject. These sculptures are manifestations of the ability of the human body to survive and dominate, no matter how catastrophic its surroundings. Fragmentary and ruinous the huge carcasses may be, but their condition is not one of collapse. Never are they merely inert. On the contrary: they take on the grandiose and enduring look of landscapes which have survived everything that Nature, and everything that ourselves, can do to destroy them. The scale, here, is immensely important and there is a radical change in the relationship between the human and the landscape element. Thirty years ago, that is to say, Moore seemed to put the human figure first: such allusions to landscape as were present had the effect of a comment on individual character. More recently, certain human attitudes linger: defiance, renewal, watchfulness, resolution. But the characterized individual has been absorbed into a general image that also includes the arches and towers of a triumphal architecture and the ridged and shadowy recesses of a mountainous landscape against which wind and water and time have done their worst. These are not sculptures with one story to tell, and they have no 'front' or 'back' and no one point from which they 'look best'. They must be toured, not quizzed; lived in, not visited; read from end to end, not encapsulated. The inspiration is so rich that Moore can afford to let our attention wander: what does not come in with one tide will come in with the next.

For this is the point of Henry Moore: that when so much around us is tending towards either hysteria or inanition, despair or an unconstructive hatred, he has an alternative attitude to offer. He knows, as he knew in 1945, what people now need most, and what they can usefully bear.

John Russell, New York 1978

Catalogue of sculptures

The catalogue illustrates all the sculptures by Henry Moore in the Tate Gallery; those in the gift are indicated by a solid square ■. Dimensions are in the order height, width, depth.

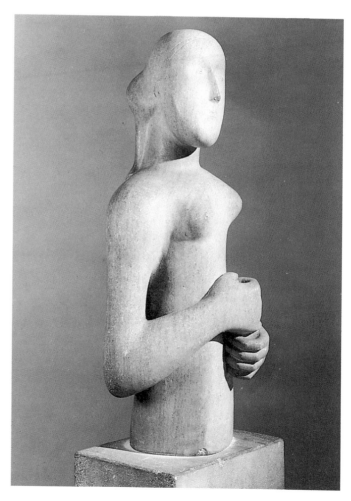

Bt Bought
Bq Bequeathed
Pr Presented
FOTG Friends of Tate Gallery
NACF National Art Collections Fund
CAS Contemporary Art Society
KF Knapping Fund
WAAC War Artists' Advisory Committee

Girl 1931
Ancaster stone
29 × 14½ × 10¾ in.
(6078)
Bt 1952

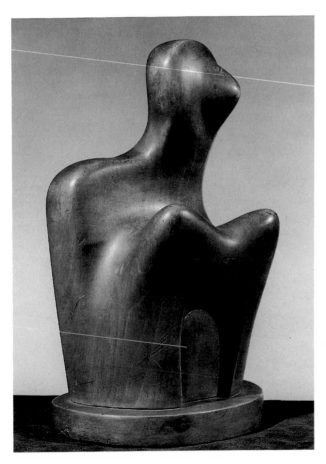

Figure 1931
beechwood
$9\frac{3}{4} \times 7 \times 4\frac{3}{4}$ in.
(T.240)
Bq. E. C. Gregory 1959

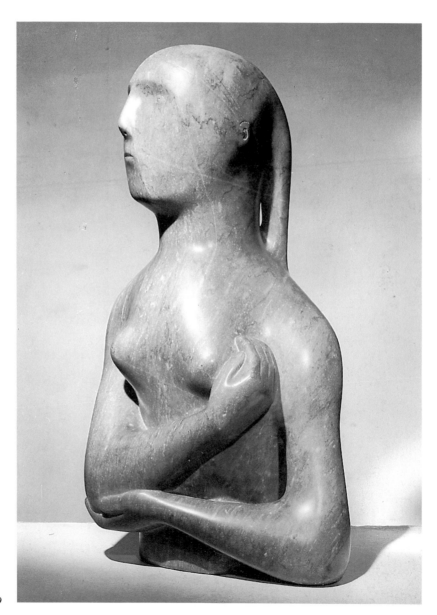

Half-figure 1932
Armenian marble
27 × 15 × 11 in.
(T.241)
Bq. E. C. Gregory 1959

Composition 1932
African Wonderstone
$17\frac{1}{2} \times 18 \times 11\frac{3}{4}$ in.
(T.385)
Pr FOTG 1960

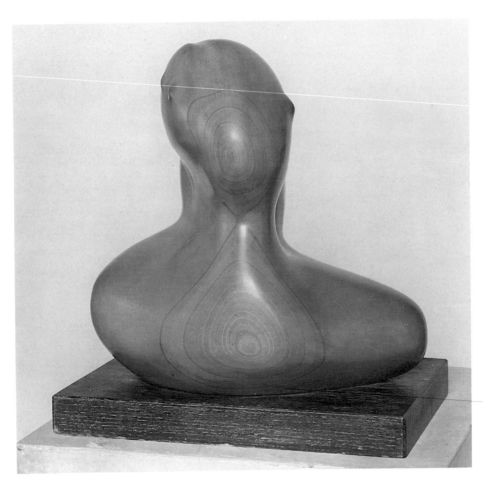

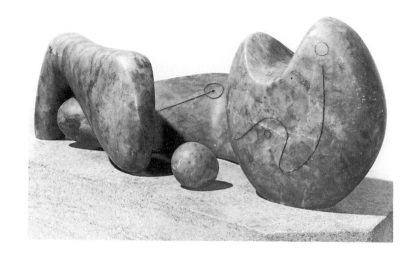

below and right
Four Piece Composition
(Reclining Figure) 1934
Cumberland alabaster
$10\frac{3}{8} \times 20\frac{3}{16} \times 10\frac{13}{16}$ in.
(T.2054)
Bt with aid of NACF 1976

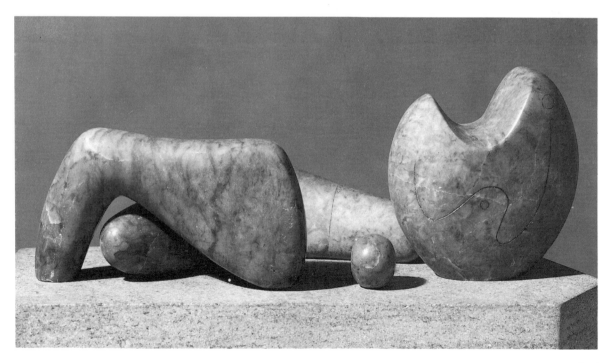

Recumbent Figure 1938
green Hornton stone
35 × 52½ × 29 in.
(5387)
Pr CAS 1939

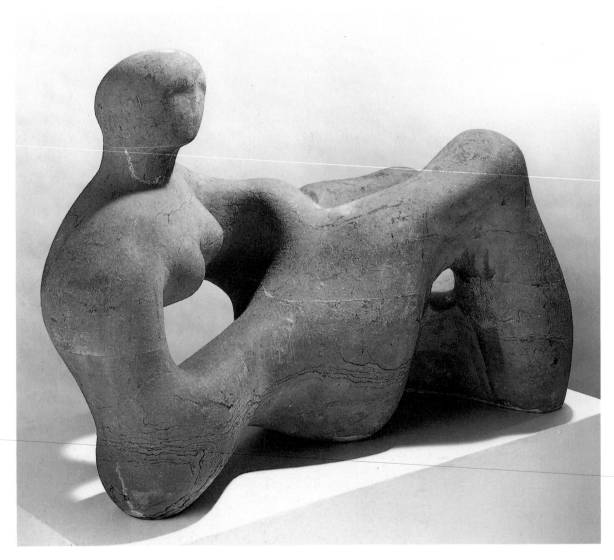

Stringed Figure 1938–60
polished bronze with
elastic string
$10\frac{3}{4} \times 13\frac{1}{2} \times 7\frac{3}{4}$ in.
(T.386)
Pr FOTG 1960

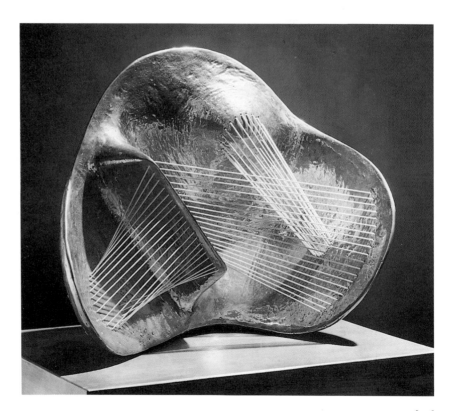

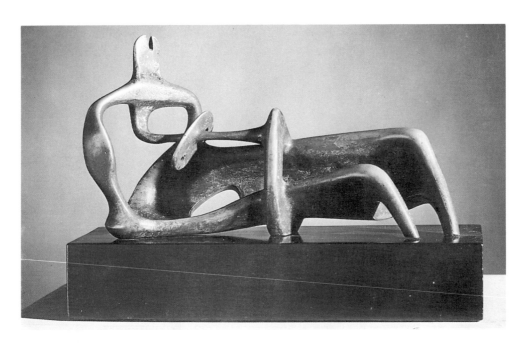

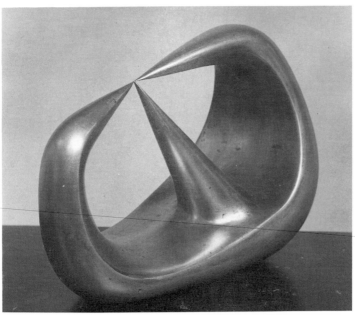

above
Reclining Figure 1939
bronze
$5\frac{3}{8} \times 10 \times 3\frac{3}{8}$ in.
(T.387)
Pr FOTG 1960

left
■ **Three Points** 1939–40
bronze
length $7\frac{1}{2}$ in.
(T.2269)

**Maquettes for Madonna
and Child** 1943
bronze

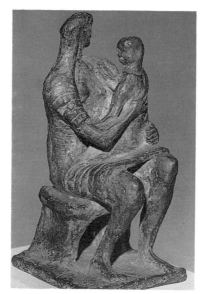

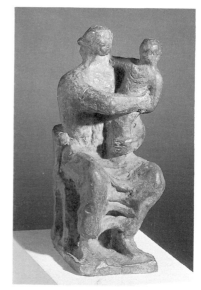

$5\frac{1}{2} \times 3 \times 3$ in.
(5600)
Bt KF 1945

$5\frac{3}{4} \times 2\frac{1}{8} \times 2\frac{5}{8}$ in.
(5601)
Bt KF 1945

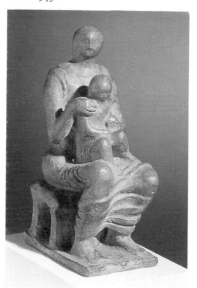

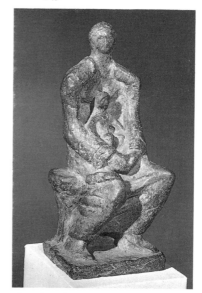

$6\frac{1}{8} \times 3\frac{3}{8} \times 2\frac{3}{4}$ in.
(5602)
Bt KF 1945

$7\frac{1}{4} \times 3\frac{1}{2} \times 3$ in.
(5603)
Bt KF 1945

right
Maquette for Family Group 1944
bronze
$5\frac{3}{8} \times 4\frac{1}{2} \times 2\frac{5}{8}$ in.
(5604)
Bt KF 1945

below left
Maquette for Family Group 1945
bronze
$5 \times 3\frac{7}{8} \times 2\frac{1}{2}$ in.
(5605)
Bt KF 1945

below right
Maquette for Family Group 1945
bronze
$7 \times 4 \times 2\frac{3}{8}$ in.
(5606)
Bt KF 1945

opposite page
Family Group 1949
bronze
$60 \times 45\frac{1}{2} \times 30\frac{3}{4}$ in.
(6004)
Bt 1950

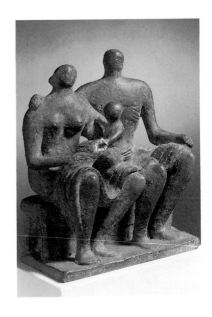

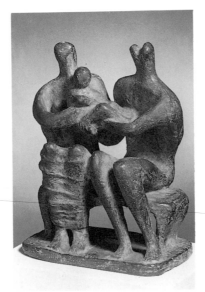

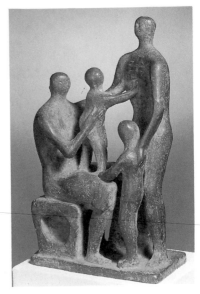

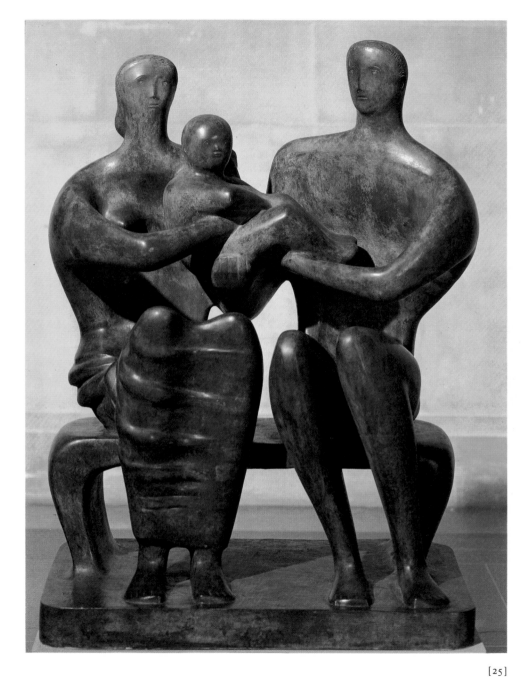

below left and right
Helmet Head No.1 1950
bronze
13 × 10¼ × 10 in.
(T.388)
Pr FOTG 1960

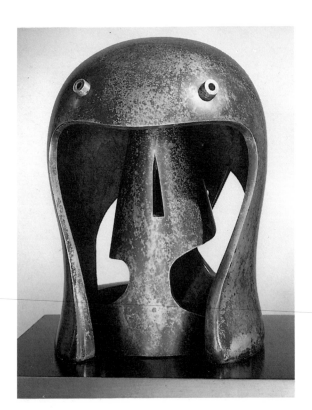
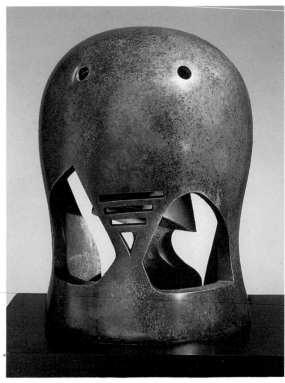

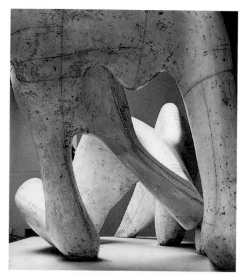

below and right
■ **Reclining Figure** 1951
plaster
$41\frac{1}{2} \times 89\frac{1}{2} \times 35\frac{1}{8}$ in.
(T.2270)

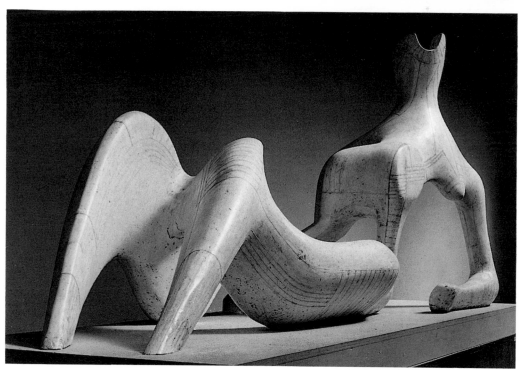

■**Animal Head** 1951
plaster
width 12 in.
(T.2271)

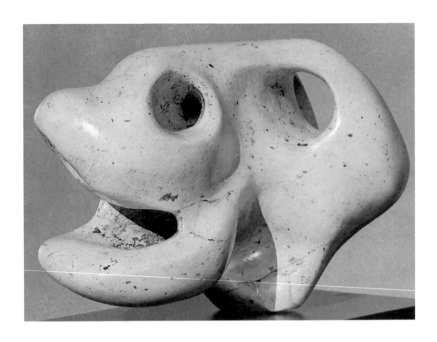

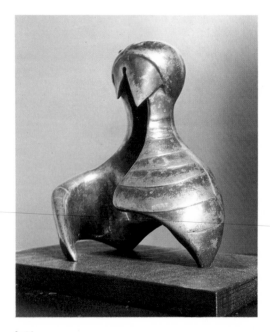

■**Helmet Head and
Shoulders** 1952
bronze
height 6½ in.
(T.2273)

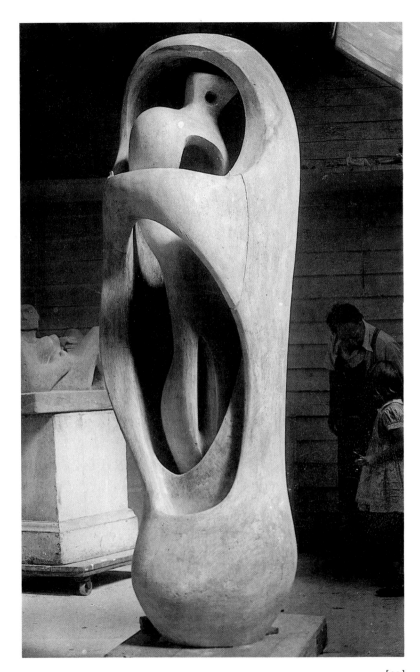

■**Upright Internal/External
Form** 1952–3
plaster
height 79 in.
(T.2272)

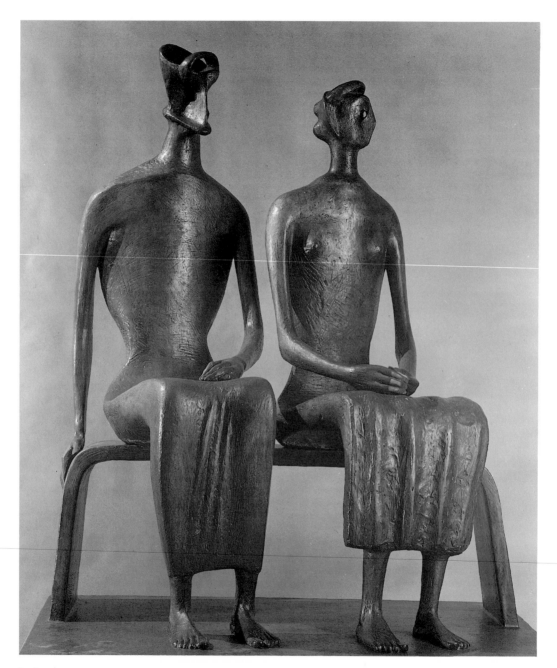

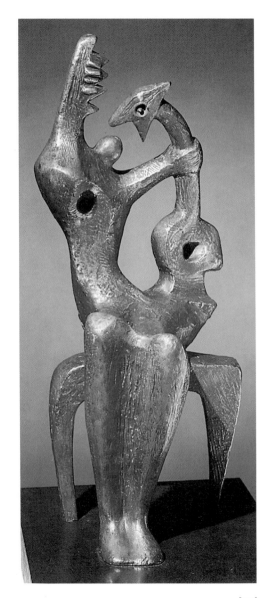

opposite page
King and Queen 1952–3
bronze
$64\frac{1}{2} \times 54\frac{1}{2} \times 33\frac{1}{4}$ in.
(T.228)
 Pr FOTG with funds from
Assoc. Rediffusion Ltd 1959

right
Mother and Child 1953
bronze
$20 \times 9 \times 9\frac{1}{4}$ in.
(T.389)
Pr FOTG 1960

[31]

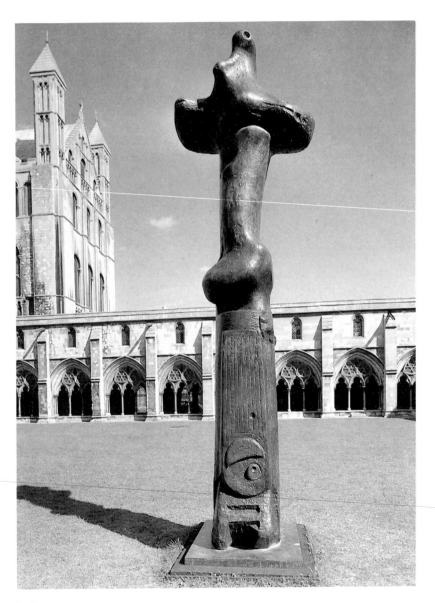

left and opposite centre
■ **Upright Motive No.1:**
Glenkiln Cross 1955–6
bronze
height 132 in.
(T.2274)

opposite left
■ **Upright Motive No.2** 1955–6
bronze
height 126 in.
(T.2275)

opposite right
■ **Upright Motive No.7** 1955–6
bronze
height 126 in.
(T.2276)

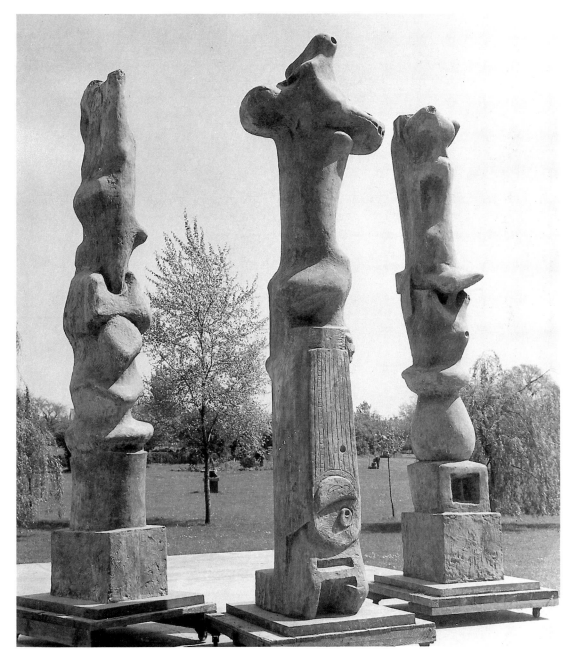

right
■**Animal Head** 1956
bronze
width 22 in.
(T.2277)

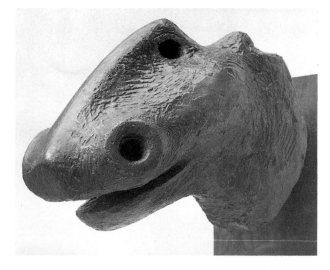

below
■**Falling Warrior** 1956–7
bronze
width 58 in.
(T.2278)

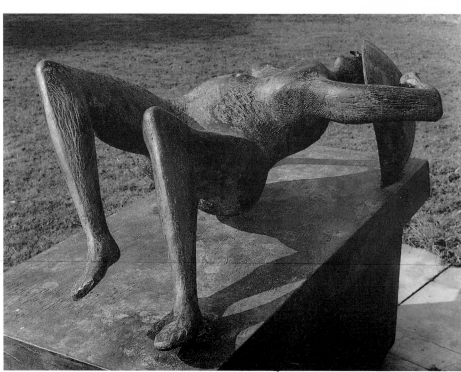

**Working model for Unesco
Reclining Figure** 1957
bronze
54 × 90 × 45 in.
(T.390)
Pr FOTG 1960

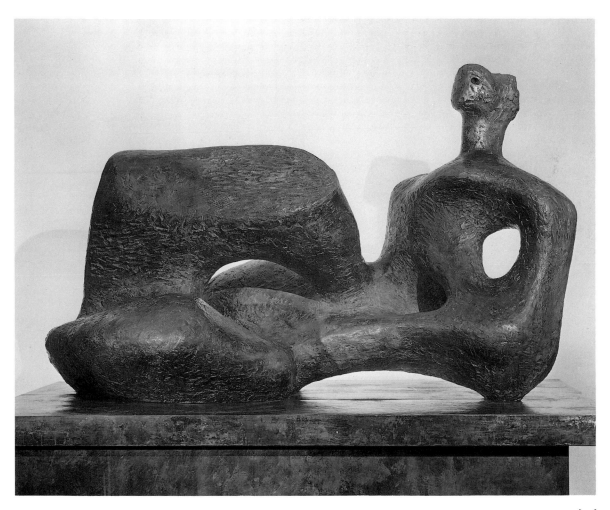

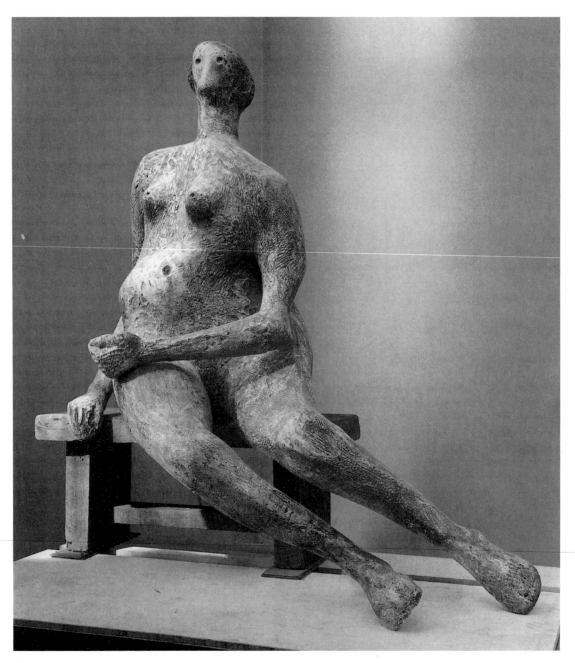

opposite page and below
■ **Seated Woman** 1957
 plaster
 height 57 in.
 (T.2279)

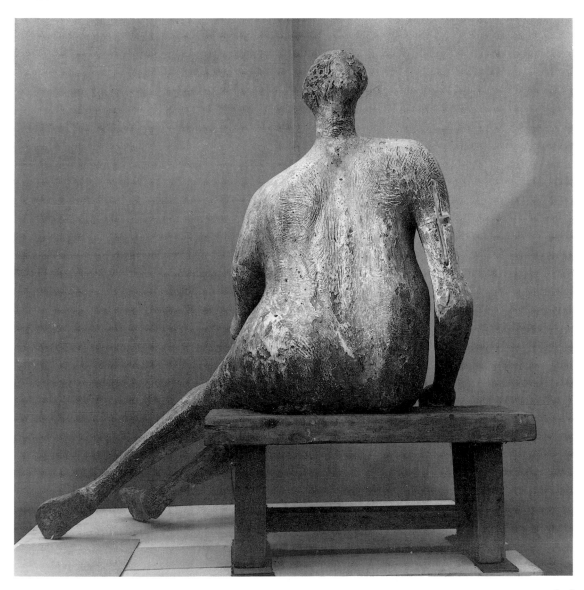

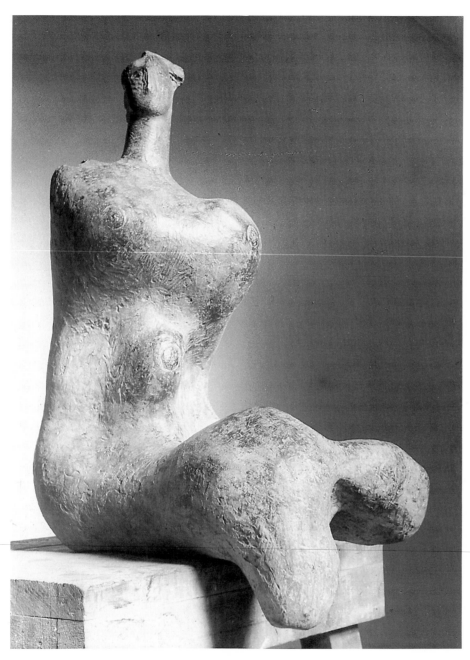

■**Woman** 1957–8
bronze
height 60 in.
(T.2280)

■ **Three Motives against Wall**
No.2 1959
bronze
width 42½ in. height 15 in.
(T.2281)

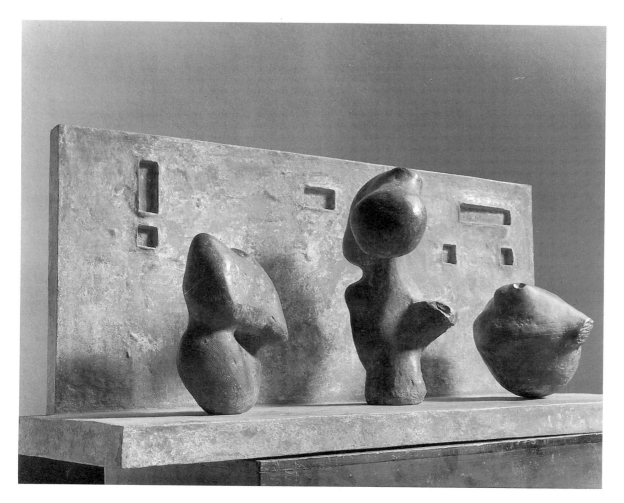

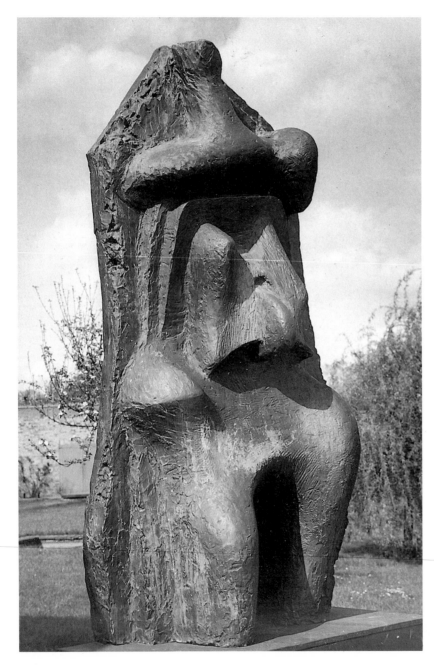

Relief No.1 1959
bronze
90 × 54 × 25½ in.
(T.2284)

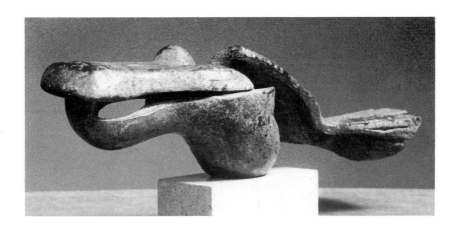

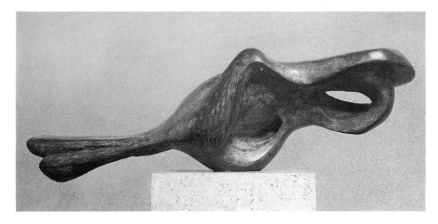

■**Bird** 1959
bronze
width 15 in.
(T.2282)

■**Headless Animal** 1960
bronze
$6\frac{1}{4} \times 8\frac{7}{8} \times 3\frac{3}{4}$ in.
(T.2283)

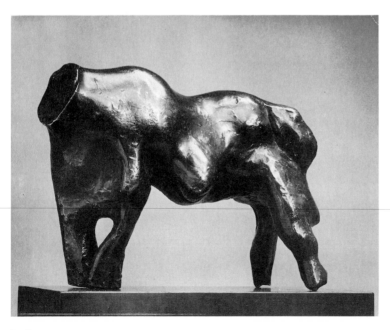

opposite page
■**Three Part Object** 1960
bronze
height $48\frac{1}{2}$ in.
(T.2285)

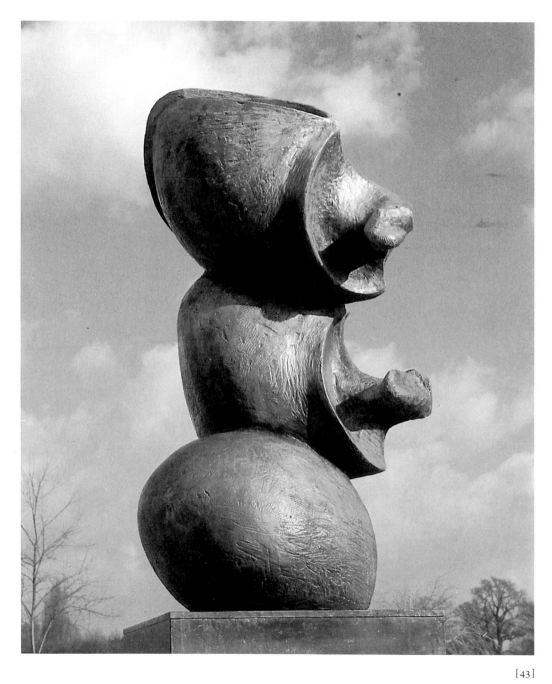

below
**Two Piece Reclining
Figure No.2** 1960
bronze
$49\frac{1}{2} \times 101\frac{1}{2} \times 42\frac{3}{4}$ in.
(T.395)
Bt 1960

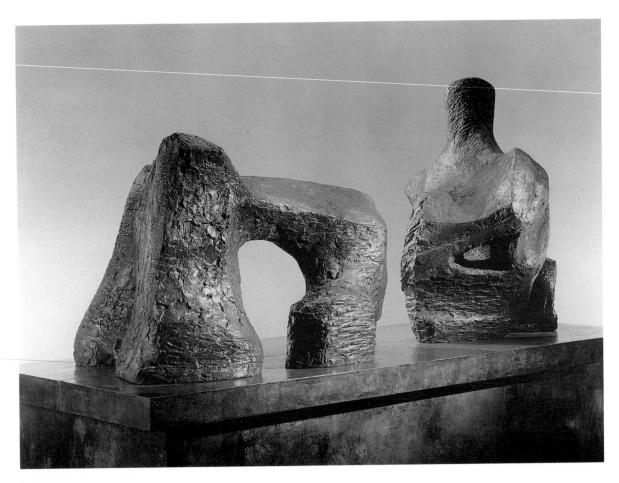

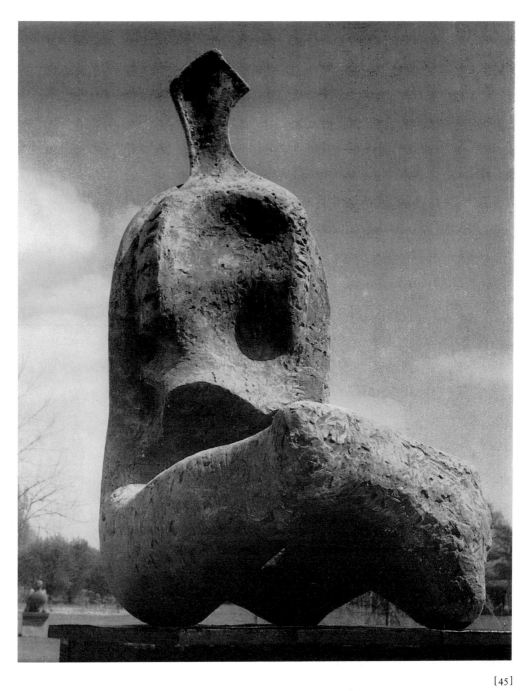

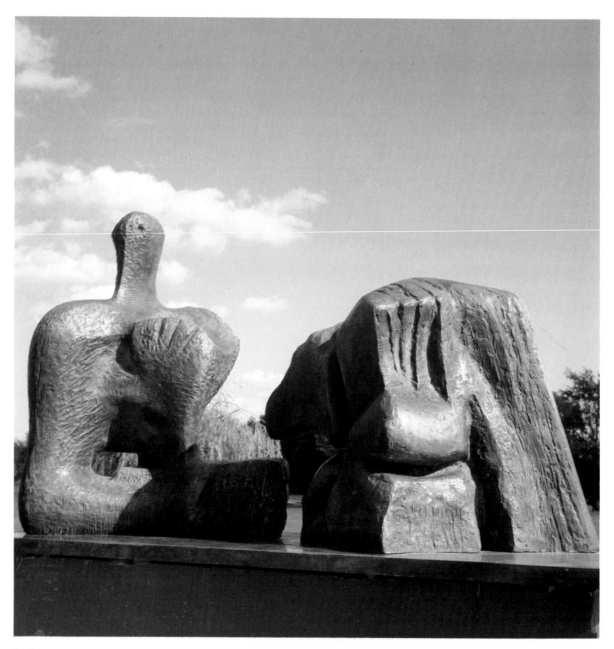

opposite page
■ **Two Piece Reclining Figure No.3** 1961
bronze
$62\frac{1}{2} \times 110\frac{1}{4} \times 54$ in.
(T.2287)

right
■ **Three-Quarter Figure** 1961
plaster
height 15 in.
(T.2288)

below
■ **Three Piece Reclining Figure No.1** 1961–2
bronze
width 113 in.
(T.2289)

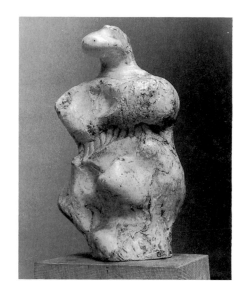

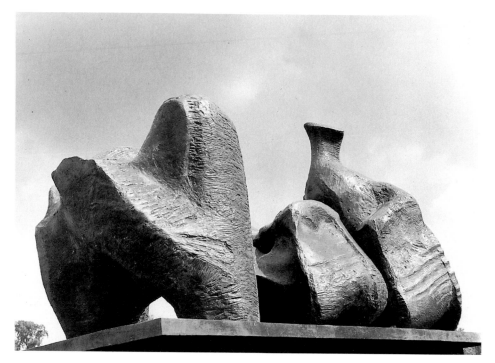

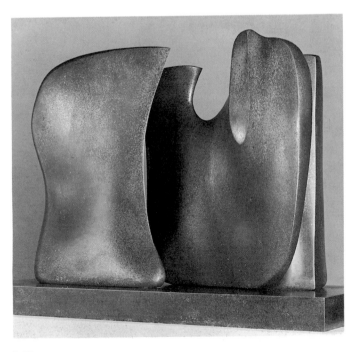

**Working model for
Knife-Edge Two Piece** 1962
bronze
height 17½ in.
(T.603)
Bt 1963

Large Slow Form:
Tortoise 1962–8
bronze
width 30¼ in.
(T.2290)

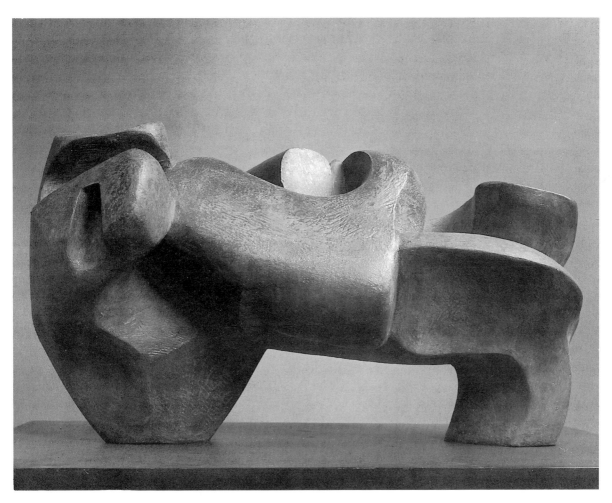

opposite page
■**Three Piece Reclining
Figure No.2: Bridge Prop** 1963
bronze
$46\frac{1}{8} \times 99\frac{1}{4} \times 52$ in.
(T.2292)

below left and right
■**Helmet Head No.4
Interior-Exterior** 1963
bronze
$21\frac{3}{4} \times 13\frac{5}{8} \times 15\frac{3}{8}$ in.
(T.2291)

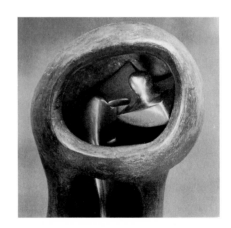

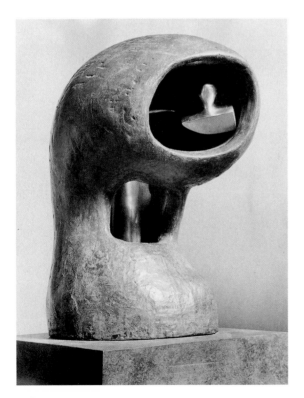

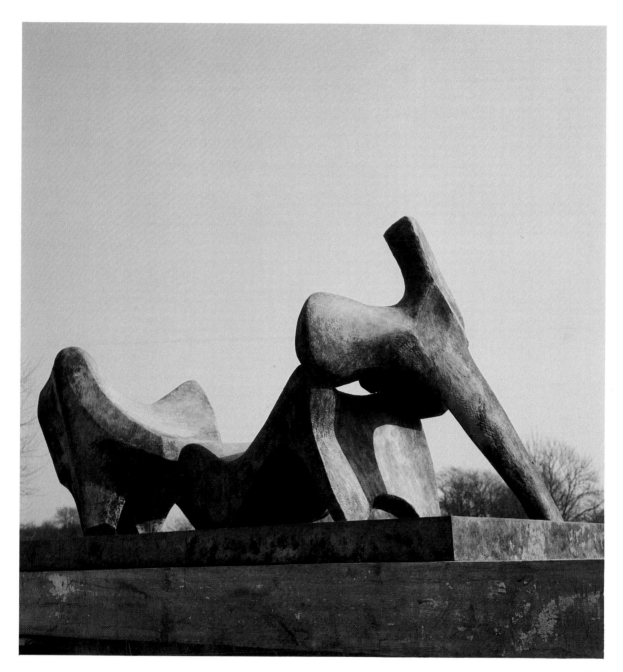

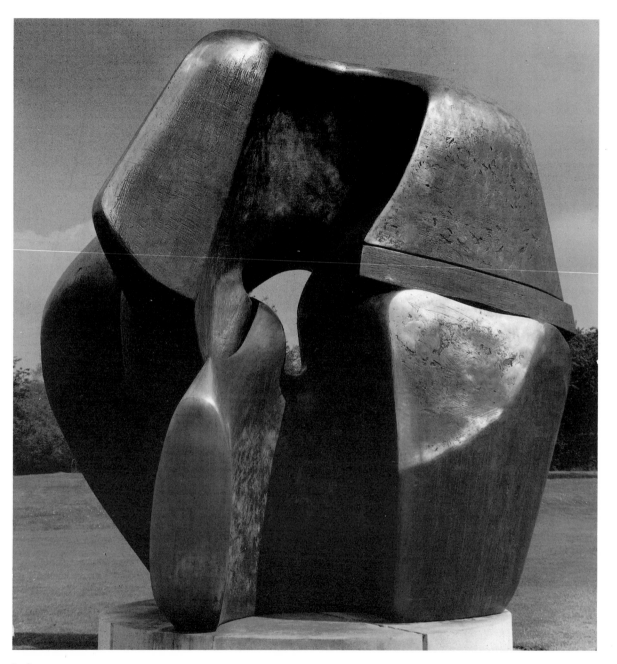

opposite page
■ **Locking Piece** 1963–4
bronze
height 115½ in.
(T.2293)

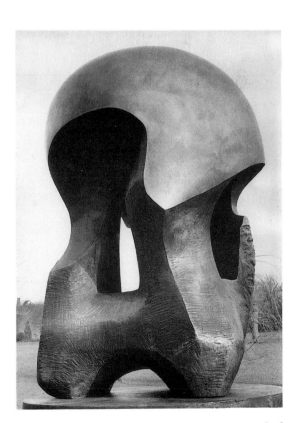

■ **Atom Piece (Working
model for Nuclear
Energy)** 1964–5
bronze
height 47 in.
(T.2296)

opposite page
■**Working model for
Reclining Figure
(Lincoln Center)** 1963–5
bronze
width 168 in. height 84 in.
(T.2295)

below
■**Two Piece Reclining
Figure No.5** 1963–4
bronze
width 147 in.
(T.2294)

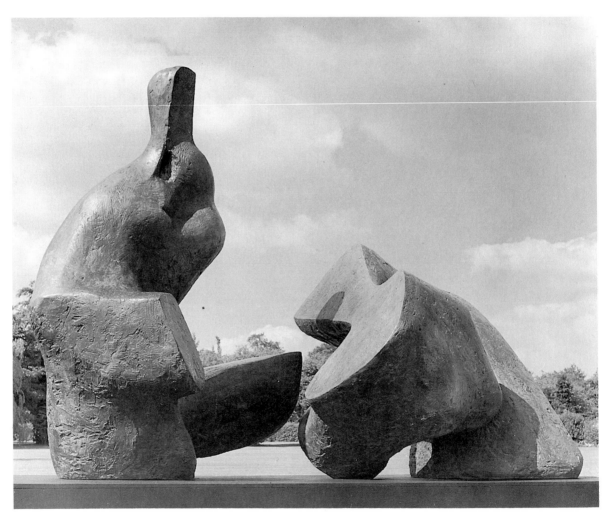

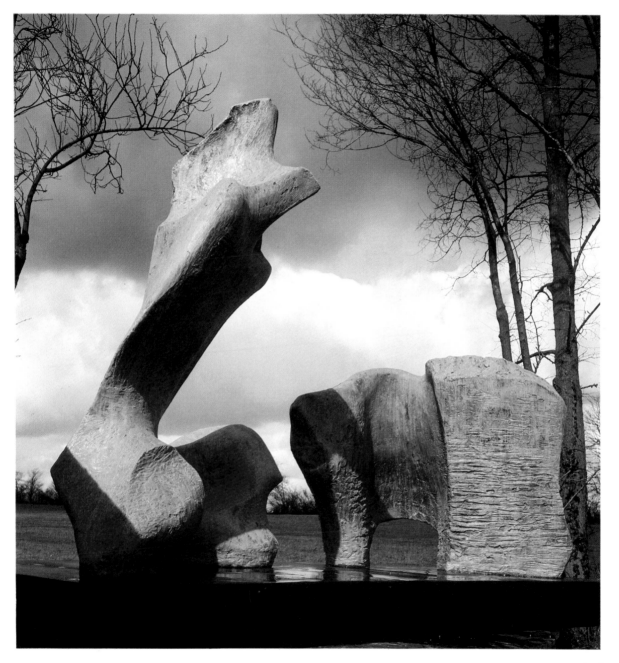

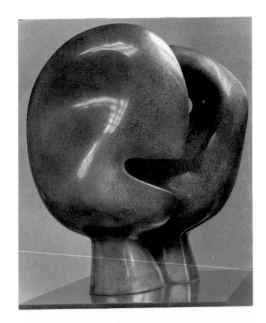

■**Moon Head** 1964
bronze
height 22½ in.
(T.2297)

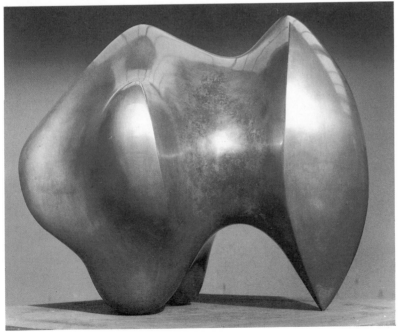

■**Working model for
Three Way Piece
No.1: Points** 1964
bronze
height 25 in.
(T.2298)

■ **Working model for**
Three Way Piece
No.2: Archer 1964
bronze
height 30½ in.
(T.2299)

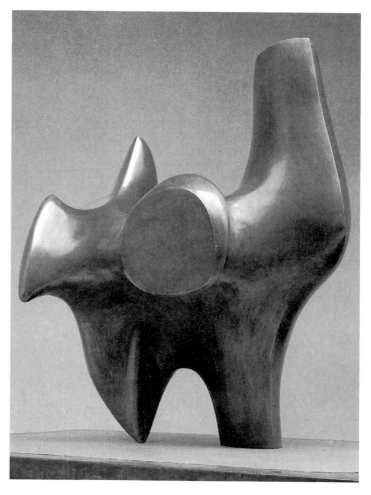

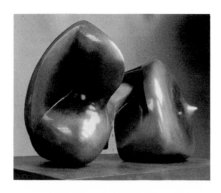

left and below
■ **Two Piece Sculpture
No.7: Pipe** 1966
bronze
width 37 in.
(T.2300)

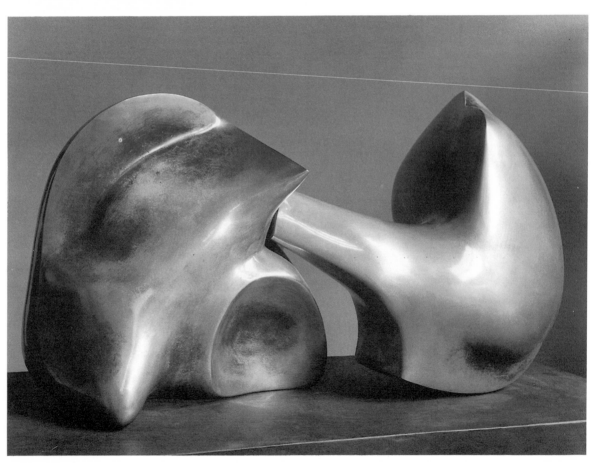

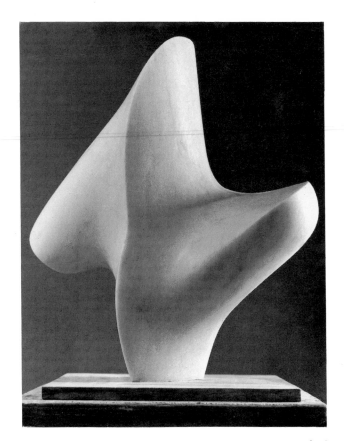

■**Upright Form:**
Knife-Edge 1966
Rosa Aurora marble
$23\frac{1}{2} \times 22\frac{1}{4} \times 9\frac{1}{2}$ in.
(T.1172)
Pr artist 1970
in memory of
Sir Herbert Read

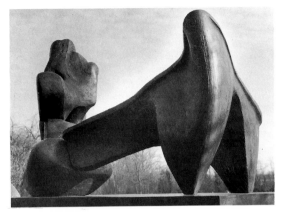

opposite page
■**Large Totem Head** 1968
bronze
height 96 in.
(T.2302)

left and below
■**Two Piece Reclining
Figure No.9** 1968
bronze
$56\frac{1}{2} \times 96 \times 53\frac{1}{8}$ in.
(T.2301)

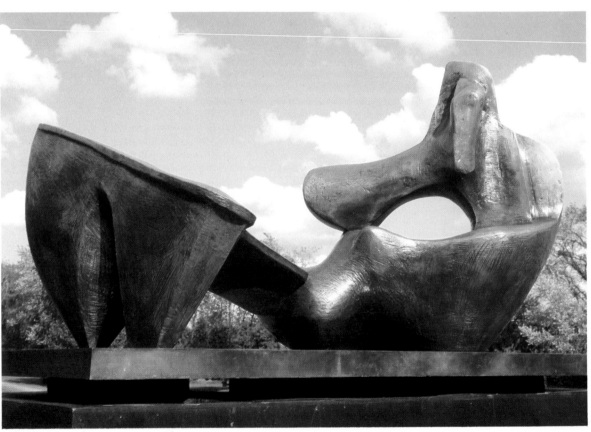

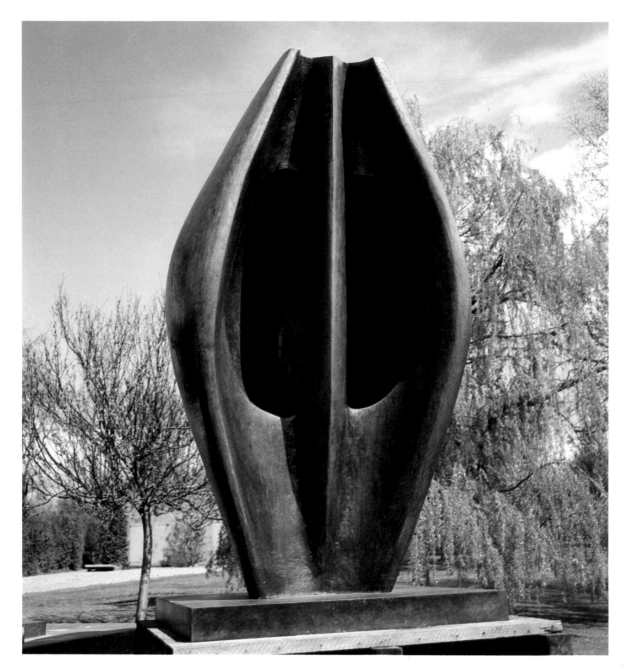

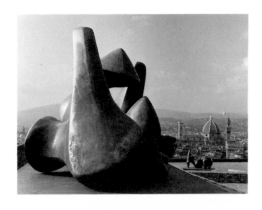

left and below
■ **Working model for Three Piece No.3: Vertebrae** 1968
bronze
width 90 in.
(T.2303)

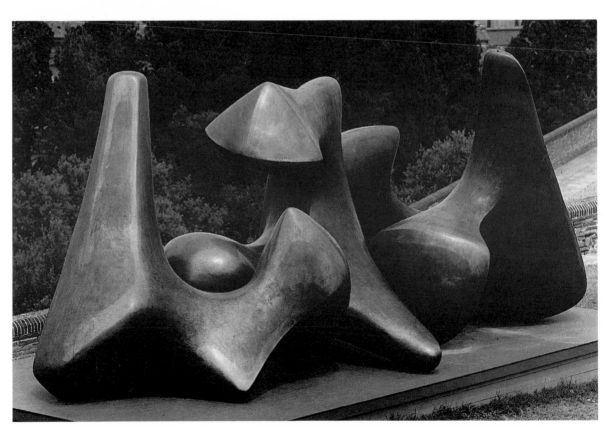

Catalogue of drawings

The catalogue illustrates all the drawings by Henry Moore in the Tate Gallery. Height precedes width in the dimensions.

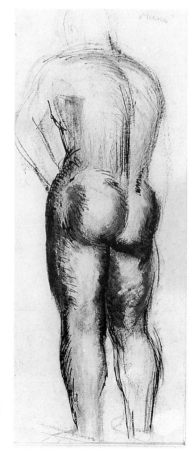

Bt Bought
Bq Bequeathed
Pr Presented
FOTG Friends of Tate Gallery
NACF National Art Collections Fund
CAS Contemporary Art Society
KF Knapping Fund
WAAC War Artists' Advisory Committee

Standing Nude c.1925
pen and chalk
22 × 9½ in. (5950)
Bt 1950

below left and right
Standing Figure 1927
chalk and wash
$21\frac{1}{4} \times 12\frac{1}{2}$ in. (T.59)
Bt 1955

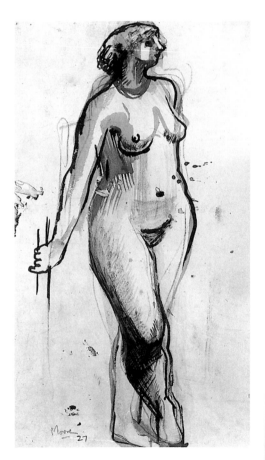

This label covers a drawing included in error.

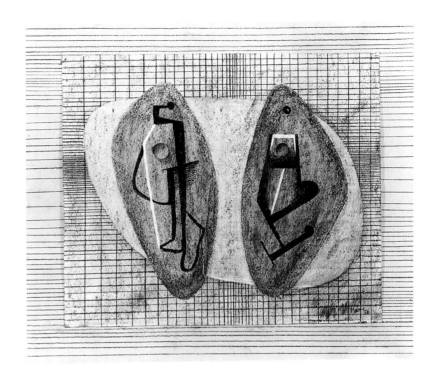

Drawing 1935
chalk and wash
$13\frac{1}{2} \times 16\frac{1}{2}$ in. (T.270)
Bt 1959

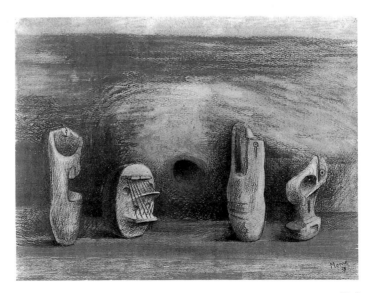

Four Forms, drawing for sculpture 1938
chalk, wash and Indian ink
11×15 in. (T.271)
Bt 1959

Standing Figures 1940
pen, chalk and gouache
$10\frac{3}{8} \times 7\frac{1}{8}$ in. (5210)
Bt 1940

Two Seated Women 1940
pen, wash, gouache and chalk
$7\frac{1}{8} \times 10\frac{5}{8}$ in. (5209)
Bt 1940

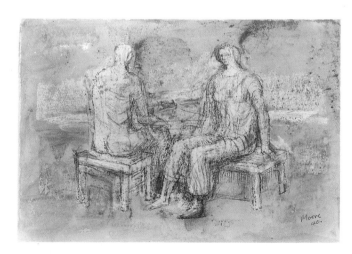

Two Seated Figures 1940
pen, wash, chalk and gouache
$7\frac{1}{8} \times 10\frac{5}{8}$ in. (5208)
Bt 1940

right
Grey Tube Shelter 1940
pen, chalk, wash and gouache
11 × 15 in. (5706)
Pr WAAC 1946

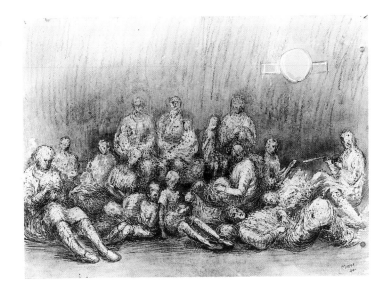

below
Shelterers in the Tube 1941
pen, chalk, watercolour and gouache
15 × 22 in. (5712)
Pr WAAC 1946

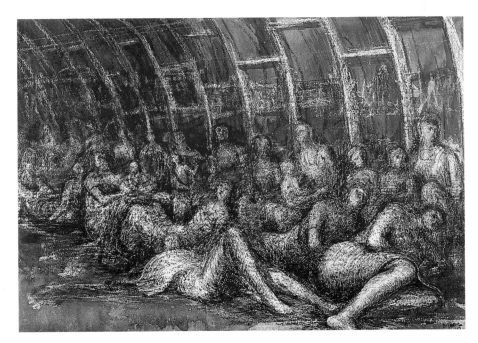

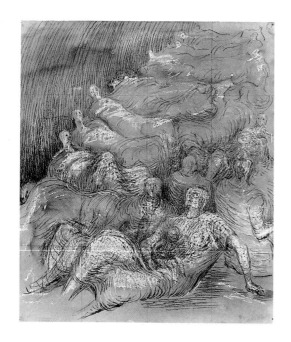

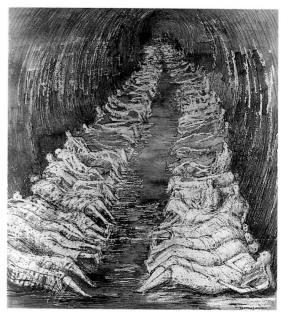

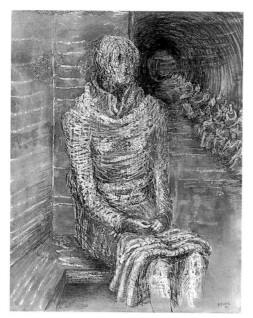

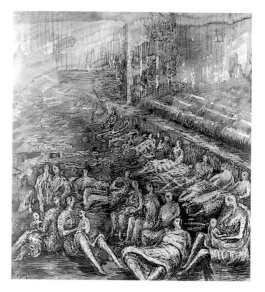

opposite page top left
Pale Shelter Scene 1941
pen, chalk, watercolour and gouache
19 × 17 in. (5710)
Pr WAAC 1946

opposite page top right
Tube Shelter Perspective 1941
pen, chalk, watercolour and gouache
19 × 17¼ in. (5709)
Pr WAAC 1946

opposite page bottom left
Woman Seated in the Underground 1941
pen, chalk and gouache
19 × 15 in. (5707)
Pr WAAC 1946

opposite page bottom right
A Tilbury Shelter Scene 1941
pen, chalk, wash and gouache
16½ × 15 in. (5708)
Pr WAAC 1946

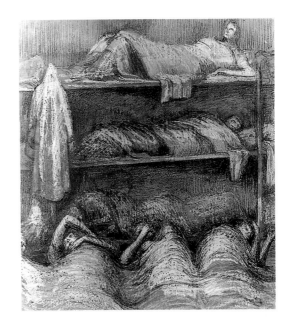

above
Shelter Scene: Bunks and Sleepers 1941
pen, chalk, watercolour and gouache
19 × 17 in. (5711)
Pr WAAC 1946

right
Pink and Green Sleepers 1941
pen, wash and gouache
15 × 22 in. (5713)
Pr WAAC 1946

[69]

Chronology

Based upon the chronology in *Henry Moore* by David Sylvester,
Arts Council (London) and Praeger (New York) 1968

1898
30 July. Born at Castleford, Yorkshire, a small mining town near Leeds. He was the seventh child of Raymond Spencer Moore (1849–1921) and Mary Baker (1860–1944). His father began work at the age of nine on a farm, but for most of his life was a coal-miner. Self-educated, he was an active Socialist and Trades Unionist.

1910
Won a scholarship from his elementary school to Castleford Grammar School.

1915
Became a student teacher, despite his ambition to be a sculptor, in accordance with his father's wish that he should first qualify in a secure profession.

1916
Took up a teaching post in September at his old elementary school.

1917
Enlisted in the 15th London Regiment. Sent to France in early summer. Gassed in the battle of Cambrai. Sent back to hospital in England early in December.

1918
After convalescence redrafted to France in November.

1919
Demobilized in February and resumed his old teaching post a month later. In September entered Leeds School of Art, where he studied for two years.

1921
Won a scholarship in Sculpture to the Royal College of Art.

1922
Began to spend his vacations in Norfolk, where he started doing sculpture out of doors.
Away from the College made his first direct carvings, in stone and in wood, influenced by primitive and archaic sculpture and by Gaudier-Brzeska and Epstein.

1923
At Whitsun made the first of more or less annual visits to Paris. Saw the Cézannes in the Pellerin collection.

1924
Awarded Royal College of Art Travelling Scholarship, but, on completing his third year as a student there, was appointed instructor in the Sculpture School. Postponed going abroad in order to take temporary charge of the department.
Carvings included first reclining figure.

1925
In France and Italy from the end of January till mid-July.

1926
Exhibited for the first time, in a mixed show at the St. George's Gallery.

1927
Helped to form a small group of young artists for an exhibition at the Beaux-Arts Gallery.

1928
First one-man exhibition: the Warren Gallery.
Began work on first public commission – a relief carving for a façade of the new Underground station building, St. James's Park.

1929
In July married Irina Radetzky, a painting student at the Royal College of Art. Moved into a studio at 11a Parkhill Road, Hampstead.
First reclining figure influenced by the Chacmool from Chichén Itzá. First cubist-inspired use of a hole in a figure composition.

1930
Elected to the 7 and 5 Society (1920–35). Members in the 1930s included Nicholson, Hepworth, Hitchens, Piper. Published his first article: a statement in a series on contemporary English sculptors, *Architectural Association Journal*, May. First article published on his work: by R.H. Wilenski, *Apollo*, December.

1931
First of his one-man shows at the Leicester Galleries.

1932
Appointed Head of a new sculpture department at Chelsea School of Art, under H.S. Williamson.

1933
Member of Unit 1, founded this year by Paul Nash. Other members included Hepworth, Armstrong, Burra, Nicholson, Wadsworth and the architects Wells Coates and Colin Lucas.

1934
Takes a cottage with a large field (where he could work out of doors) at Kingston,